	DATE DUE		

NATIVE ❖ LATIN ❖ AMERICAN ❖ CULTURES

THE ARTS

Rebecca Clay

Series Editor
Robert Pickering, Ph.D.

❖ ❖ ❖

ROURKE PUBLICATIONS, INC.
Vero Beach, Florida 32964

Printed in the United States of America.

A Blackbirch Graphics book.

Senior Editor: Tanya Lee Stone
Assistant Editor: Elizabeth Taylor
Design Director: Sonja Kalter

Library of Congress Cataloging-in-Publication Data

Clay, Rebecca, 1956–
The Arts / by Rebecca Clay.
 p. cm. — (Native Latin American culture)
 Includes bibliographical references and index.
 ISBN 0-86625-551-6
 1. Indian art—Mexico. 2. Indian art—West Indies. 3. Indian art—South America. 4. Indians of Mexico—Material culture. 5. Indians of the West Indies—Material culture. 6. Indians of South America—Material culture. I. Title. II. Series.
F1219.3.A7C48 1995
709'.8—dc20
 94-48996
 CIP

Contents

Introduction

The towering temples and fierce warriors of the Aztecs, the sophisticated lords of the Maya, and the vast empire of the Inca that extended along the Andes are all images that come to mind when the native cultures of Mexico, Central America, and South America are mentioned. While these images are real, they are only a small part of the story of the indigenous peoples of the Americas. More important, there are hundreds of other cultures that are not as well known, but just as interesting. To explore the cultures of this huge area is to examine the great diversity and richness of humanity in the Americas.

This series on *Native Latin American Cultures* presents six books, each with a major theme: the arts, daily customs, spirituality, trade, tribal rules, and the invasion by Europeans. It focuses mainly on pre-Columbian times (before the arrival of Columbus in the New World) through about 1800. These books illustrate the ingenuity, resourcefulness, and unique characters of many cultures. While a variety of tribes share similarities, many are extremely different from one another.

It is important to remember that the Americas were home to people long before Europeans arrived. Archaeologists have uncovered sites as old as 12,000 years. Over the years, human cultures in every part of the Americas developed and evolved. Some native cultures died out, other peoples survived as hunter-gatherers, and still others grew to

create huge empires. Many native languages were not recorded and, in some instances, they have been forgotten.

But other groups, such as the Maya, did record their languages. Scientists are just now learning to read the Mayan language. Mayan stories tell of the power and glory of great rulers, heroic battles between city-states, and other important events. Massive stone temples and ruins of cities have survived from several cultures, giving us insight into the past.

Many native cultures of the Americas exist today. Some have blended with the modern cultures of their countries while maintaining their traditional ways. Other, more remote groups exist much as they did several hundred years ago. The books in the *Native Latin American Cultures* series capture the richness of indigenous cultures of the Americas, bringing past cultures alive and exploring those that have survived.

Robert Pickering, Ph.D.
Department of Anthropology
Denver Museum of Natural History

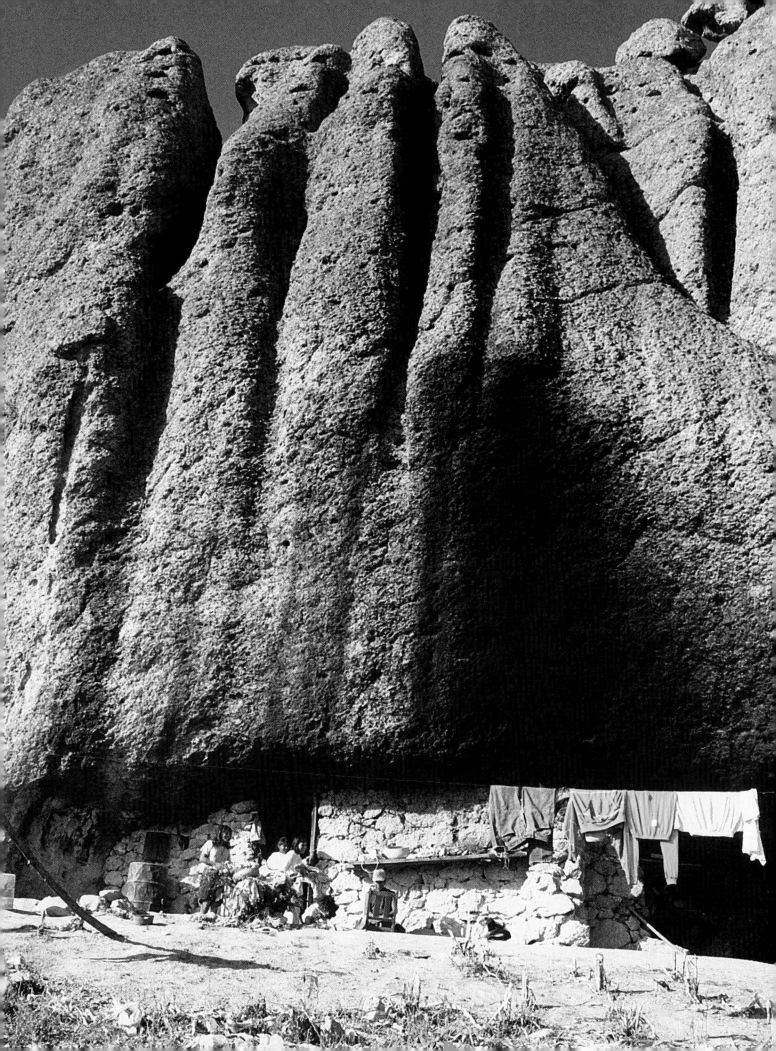

Northwestern Mexico

The thousands of years before the arrival of Christopher Columbus in 1492 in the New World are called the pre-Columbian period. The hundred-year span of time after the explorer's landing in the Caribbean—a period of rapid invasion and colonization—is often referred to as the Spanish conquest. This is because the Spanish in effect conquered the New World.

After their first landings in the Caribbean, the Spanish began to spread west across the rich and fertile plateaus of central Mexico. By the time they arrived in northwest Mexico, they had destroyed much of the Aztec and other sophisticated civilizations to the east. Northwest Mexico had few of the massive buildings and beautiful cities that central Mexico did. Since the people there appeared not to have gold or riches, the Spanish did not conquer the region in the same brutal manner.

Opposite:
For many centuries, the Tarahumara were protected from invaders by the sheltered canyons of northwestern Mexico. Here, a Tarahumara family does chores outside of its rock-shelter home.

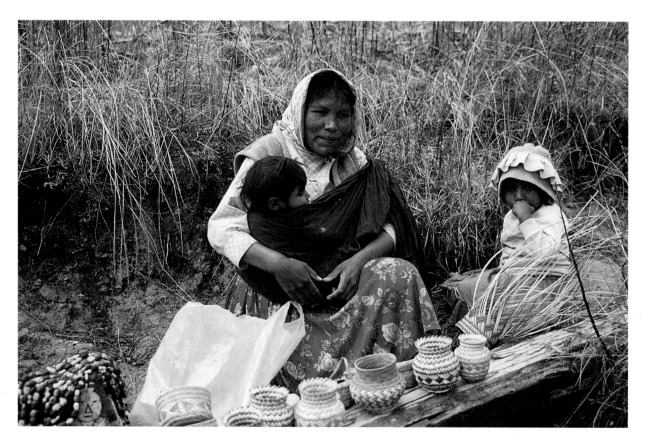

A Tarahumara
woman and her
children sell
traditionally made
baskets by the side of
the road.

The mountains and desert of northwestern Mexico provided the Tarahumara, Seri, and Huichol tribes, among others, with a natural protective barrier against invaders. Because they lived on the rugged northwestern side of Mexico, far from the Atlantic Ocean and the invading Spaniards, most native peoples in this region did not see their first Europeans until more than one hundred years after Christopher Columbus's arrival in the New World. This allowed them to maintain many of their cultural traditions for centuries, although Spanish customs later became important influences.

Today, several northwestern Mexican groups continue to practice many of their traditional arts and crafts, although in some cases new products, such as acrylics, have been used alongside wool, and natural dyes have been replaced by synthetic ones. Textiles, pottery, and baskets, especially, are still made and decorated as they were in the past. Many of these products are now sold to the millions of tourists who visit Mexico each year.

The Tarahumara

Because they made their homes within very deep canyons and along high plateaus, the Spanish did not reach the Tarahumara until 1605. For many centuries, they lived in the western Sierra Madres, in the Mexican state of Chihuahua, about 200 miles from the United States border. Today, the Tarahumara are considered the largest group of North American Indians to preserve their native way of life. Although they lived in a dry area, they found abundance in nature.

The Tarahumara had an artistic tradition of making objects that were both functional and decorative. They used such articles as butterfly cocoons, wool, and animal skins to fashion belts and masks, among other things. They often designed their necklaces and earrings from seeds, shells, pieces of reed, and tiny balls of wood or clay. A leather belt might be decorated with deer hooves, which rattled as the wearer walked. After the Spaniards' arrival, the Tarahumara began to use metals and trinkets acquired through trade.

Another decorative but useful article was the *olla*, a large earthenware jug made by Tarahumara potters and used for storing beer. The beer, made from fermented corn and called *tesguino*, is still very popular among the Tarahumara. At parties, men and women are served the *tesguino* from large *ollas*, and each guest drinks from gourds that are dried and cut in half.

Before the conquest, men often wore wool sashes over loincloths. When Christian missionaries arrived from Spain, they tried to persuade the Tarahumara to wear European-style shirts and trousers. Most of the Tarahumara refused, although they did begin to use cotton fabrics brought over by the Spanish.

For weaving, Tarahumara women used rigid square looms rather than the backstrap looms used by other Mexican Indians. They wove wool sashes and blankets on

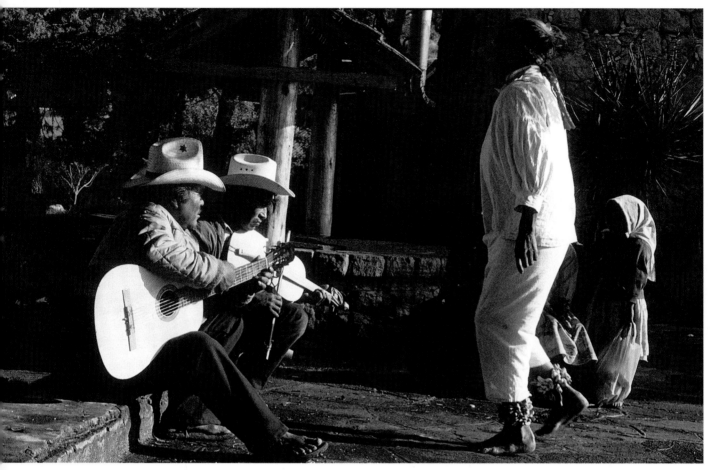

A Tarahumara dancer uses traditional ankle rattles made of moth cocoons, while musicians play instruments introduced to them by the Spanish.

these looms for centuries. Both men and women often wore these blankets as clothing. To color their fabrics, they used dyes made from natural products, such as fruit, flowers, leaves, bark, and wood. To create a reddish yellow, for example, the Tarahumara mixed lichens with alum, a naturally occurring mineral.

Traditional Tarahumara musical instruments included rattles and flutes made by hand from reeds. When the Spanish introduced sugarcane to Latin America, the Tarahumara began to use the cane to make their flutes. They formed rattles out of hollowed wood filled with pebbles. These rattles were often used during ceremonies and rituals. The Tarahumara also learned from Spaniards how to make and play violins. The violin is now a favorite instrument in many Tarahumara households. While accepting such innovations, the Tarahumara managed to preserve their cultural traditions and remain a strong society.

The Seri

The Seri Indians also maintained their cultural identity. The Seri live in the state of Sonora, in northwestern Mexico. This region is named after the Sonora Desert, which spreads into southern Arizona and California, and the Sonora River, which flows into the upper part of the Gulf of California. Because they lived close to the Gulf, the Seri made some of their clothing from pelican skins.

Because of their isolation, the Seri developed several distinctive styles in their arts and crafts, notably their jewelry and basketry. However, they did influence, and were influenced by, the other native peoples who shared their region, such as the Tarahumara and the Huichol.

Like the Tarahumara, Seri women wore traditional necklaces and earrings made from seeds, seashells, pieces of reed, and tiny balls of wood or clay. Some necklaces were long and heavy, hanging down to the navel. The Seri also liked to work with wood, carving and polishing delightful figures inspired by the nature around them.

To create their baskets, the Seri wrapped multicolored strips of palm leaves around a base of grasses. Unlike other groups, however, they wrapped the leaves so tightly that the baskets were able to hold liquids as well as dry goods. The fibers, which were both light and dark, expanded when they became damp, creating beautiful geometric patterns.

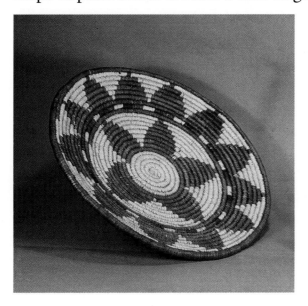

Using ancestral methods, a Seri artist created this multi-patterned basket.

❖

The Huichols

What beautiful hills, what beautiful hills,
so green here where we are.
Do not weep, brothers, do not weep,
we have come here to be happy,
we have taken this path
to find our lives.

For we are all,
we are all the children
of a flower of brilliant colors,
of a burning flower.
And here there is no one
who regrets what we are.

- A Huichol Sacred Song

The Huichols were also isolated from the outside world by the mountain peaks and deep canyons of northern Mexico. Like many neighboring groups, they often wore the *quechquemitl*, a closed shoulder-cape developed more than 1,500 years ago. This cape is still worn by Huichols and other Mexican native peoples today. European missionaries introduced shirts and trousers to the Huichols, but the Indians wore them without zippers or buttons, and they decorated their clothing with embroidered designs of eagles and deer.

Like many other pre-Columbian groups, the Huichols used a spindle to spin undyed wool. A spindle is a round stick with tapered ends that forms and twists the yarn during the spinning process. A whorl is used to weigh down the spindle and help it rotate as it twists the yarn. The Huichols made their whorls out of gourd, bone, or pottery rather than the clay or wood used by their neighbors.

From the spun wool, the Huichols wove sashes and small bags. They also made woven offerings to the gods, called *tsikuri*, or gods' eyes. Usually of two colors, the darker center of the *tsikuri* was designed to let the gods view their worshippers. Another common Huichol offering was a prayer arrow, which featured tiny pieces of embroidered cloth pierced by feathered arrows.

As it did for many native groups, Huichol clothing had both a spiritual and a functional role. Designs were meant to be visual prayers and protect wearers from harm. Long, winding sashes looked like snakes and were believed to help bring rain. Jewelry designs, including images of scorpions and butterflies, were often drawn from nature. Zigzag lines represented lightning and rain.

Although many missionaries tried to convert the Huichols to Christianity, they were unsuccessful. The Huichols maintain their own religious beliefs and customs today. Two important Huichol gods are Grandfather Fire, who provides warmth and cooks their food, and Grandmother Growth, who provides fresh spring water and vegetation.

Wearing embroidered capes and colorful feather headdresses, Huichol Indians from Mexico participate in a celebration.

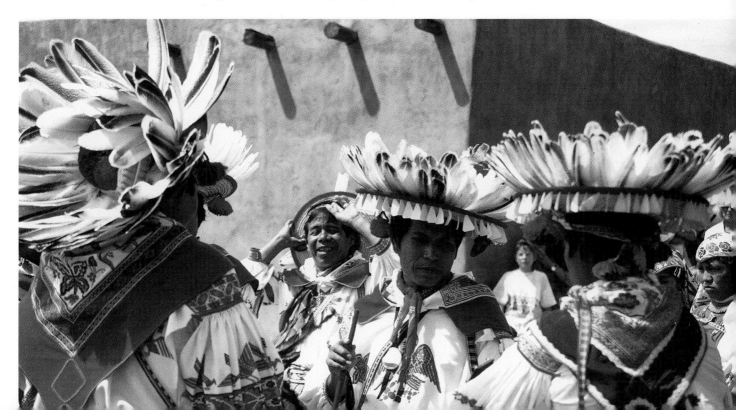

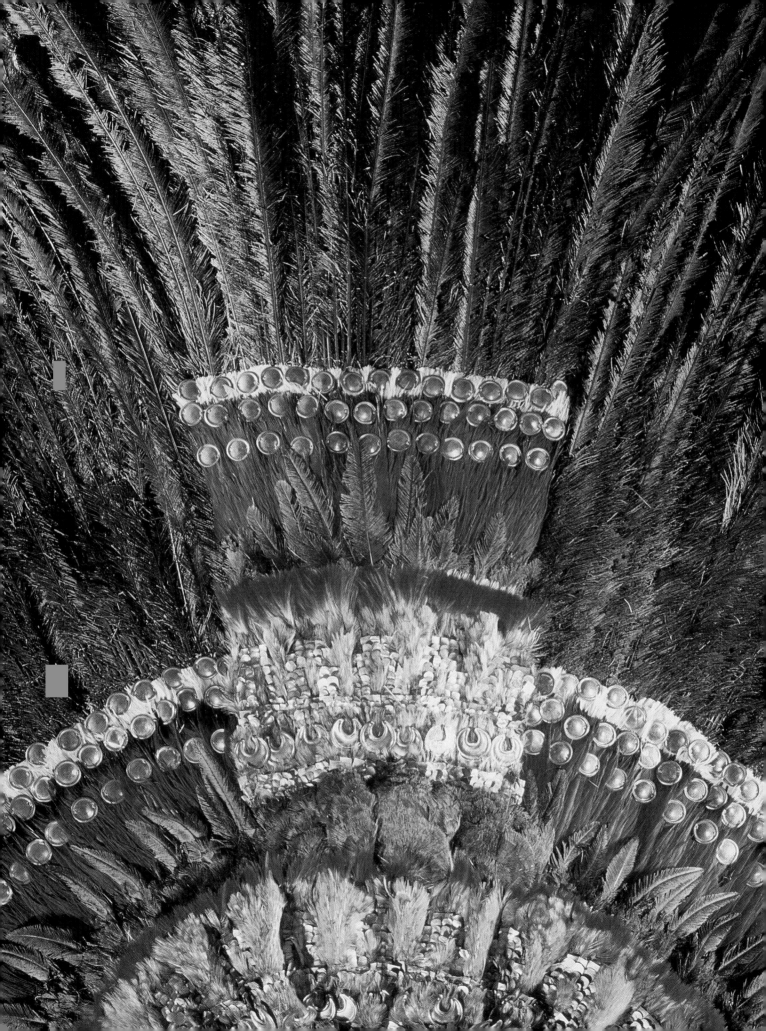

Central Mexico: The Olmecs, Toltecs, Mixtecs, and Aztecs

The major tribes that flourished in central Mexico from about 1500 B.C. to A.D. 1500 were the Aztecs, Olmecs, Toltecs, Mixtecs, and Maya. Although the Aztec civilization is the best known of the central-valley societies, it learned many of its craft skills and adapted some of its cultural traits from the other groups.

Much of what we know about the history of this region has come from the work of archaeologists and anthropologists. Archaeologists are scientists who study the material remains of past human life and activities. Anthropologists study the relationships between living people, their culture, and their environment.

Opposite:
The green feathers of the quetzal bird were used to make this stunning feather headdress of an Aztec priest in the early 1500s.

15

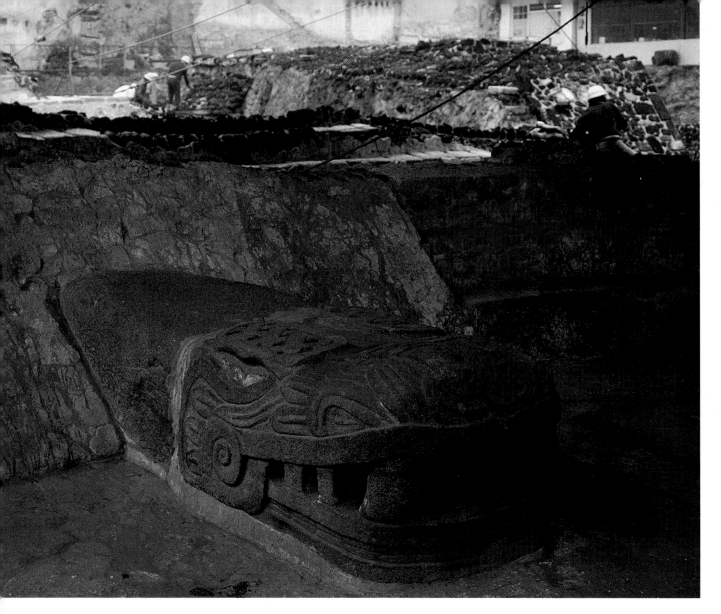

Workers carefully unearth the remains of an Aztec temple in Mexico City. Scientists have been able to decipher the history of pre-Columbian civilizations by studying the art and architecture that they have left behind.

For example, in central Mexico, many archaeologists have excavated, or dug up, the ruins of pre-Columbian civilizations. They carefully examine such things as skeletons, temples, and pieces of pottery to try to understand what the people and their communities were like.

Pre-Columbian civilizations practiced many arts and crafts, including architecture, sculpture, metalwork, pottery, featherwork, lapidary (the art of cutting precious gems and stones), and weaving. The variety of their work was stunning, ranging from massive stone temples to eggshell-thin ceramics. Some groups colored the feathers of tropical birds and decorated royal robes and warrior shields with them. They also polished semiprecious stones, such as turquoise and jadeite, to make fine jewelry. Master artisans developed in these cultures, the artistic equals of Michelangelo and Renoir.

Some archaeologists believe that pottery making was the greatest of all pre-Columbian crafts. As people began to settle in farming communities, by the year 1200 B.C., they started to create pottery figurines and utensils. Over the centuries, native groups transformed the clay into water-storage jars, pots, dishes, jewelry, flutes, rattles, incense burners, ritual vessels, urns, idols, and roof ornaments for temples. Clay was also used to make figurines of animals, human beings, and birds. In Aztec markets, fifteenth-century Spanish explorers reported that they saw "pottery of all kinds, from big water-jars to little jugs."

The study of scientifically excavated pottery has greatly helped archaeologists to determine the age and location of Mexico's ancient civilizations, as well as to learn about their trade relationships with one another. Ancient peoples used materials that did not easily decay, so there is a lot of pottery in the region that has survived for many centuries.

Although many of the great pre-Columbian civilizations lived hundreds or even thousands of years apart, there are certain similarities in the images and symbols they used in their arts. For example, the plumed serpent, an ancient deity called Quetzalcoatl, appears in Olmec, Toltec, and Aztec arts.

The jaguar was also a common image, first used around 1500 B.C. by the Olmecs. The most feared predator in Central and South America, the jaguar had great physical strength, cunning, and endurance. Jaguars were also quite skillful on land, in water, and in the trees. Warriors could identify with jaguars because they were aggressive, fearsome, and roared like thunder.

The Olmecs

The Olmecs flourished for 400 years between 1500 and 100 B.C., long before the Aztecs, Toltecs, and Mixtecs. Experts believe that the Olmec was "the mother culture" of all

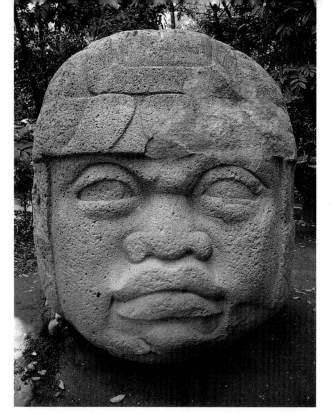

Giant stone heads, such as this one, were carved by Olmec artists. These heads were usually made of basalt, and could weigh as much as fifteen tons.

Mexican civilizations. Evidence for this idea has been found in many aspects of culture, including the arts. The Olmecs seem, for example, to have been the first group to use the image of a half-jaguar, half-human form in their art.

A Mexican art historian, Miguel Covarrubias, once called the Olmecs a "great and mysterious race of artists. Everywhere there are archaeological treasures that lie hidden in the jungles and under the rich soil of southern Veracruz, burial mounds and pyramids, masterfully carved colossal monuments of basalt, splendid statuettes of precious jade, and sensitively modeled figures of clay, all of an unprecedented, high artistic quality."

The mysterious half-jaguar, half-human figure is called a were-jaguar. (It is similar in concept to the combination wolf and human called a werewolf.) The Olmecs' territory was a preferred environment of the jaguar because of its many swamps and waterways. Olmec artists also used eagles' feathers and claws to create fantastical creatures that combined aspects of the serpent and the bird with the jaguar.

Some archaeologists also believe that the Olmecs were the first pre-Columbian people to use a fine white clay called kaolin to make decorated and carved pottery and figurines. They found rich deposits of the clay near an area called Chalcatzingo in Morelos, a modern state in south-central Mexico.

The Olmecs also used such precious and exotic materials as jade, serpentine, and schist in their arts and crafts. Serpentine is a green rock, and schist is a crystalline rock. The Olmecs also highly valued the dark, lustrous volcanic glass called obsidian, with which they made mirrors and ceremonial knives.

The Toltecs

The Toltecs were greatly admired by other cultural groups that lived both at the same time and later. Archaeologists now believe that the Toltecs were models for the first Aztecs, who were farmers. Early Aztec legends often painted the Toltecs in glorious, heroic colors. The Aztecs considered the Toltecs to be great conquerors, and the mightiest Aztec families often claimed to be descendants of them.

In the early sixteenth century, one Aztec man told a Spaniard that "the Tolteca were wise. Their works were all good, all perfect, all marvelous…in truth they invented all the wonderful, precious and marvelous things which they made."

The Toltec civilization flourished from the eighth to the thirteenth centuries A.D. Their capital city was Tula. Their religion and much of daily life centered on human sacrifice to their gods. They believed that the gods needed human blood for their own survival—and that the Toltecs' own existence depended on the gods. Therefore, they built pyramids, statues, and plazas for ritual sacrifices.

Like the Olmecs before them, the Toltecs often used symbols of the wildlife around them, especially jaguars, fanged serpents, and birds. Their most powerful images featured the plumed serpent, known as Quetzalcoatl, and the rain god, Tlaloc—two symbols that the Aztecs later borrowed. Such images were often featured on masks, statues, and the icons used during rituals and ceremonies.

The Toltecs often attacked and invaded neighboring villages, both to obtain prisoners of war for sacrifices and to expand the amount of land they ruled. Toltec warriors were fierce and most often successful in their battles. At the height of their civilization, they controlled the northern parts of the valley of Mexico and much of the state of Hidalgo. Ceremonial architecture in Tula glorified the

Toltec soldiers, depicting fierce men carrying spear throwers and darts and wearing quilted armor, round shields, and hats topped with feathers.

Huge *chacmools*, or reclining stone figures, often dominated Toltec temples and pyramids. They were most often found at the top of a pyramid's staircase. *Chacmools* held round dishes on their bellies, which were probably designed to hold the hearts of enemies sacrificed after a war.

The Mixtecs created beautiful objects from things found in nature, such as this coral and jade mask.

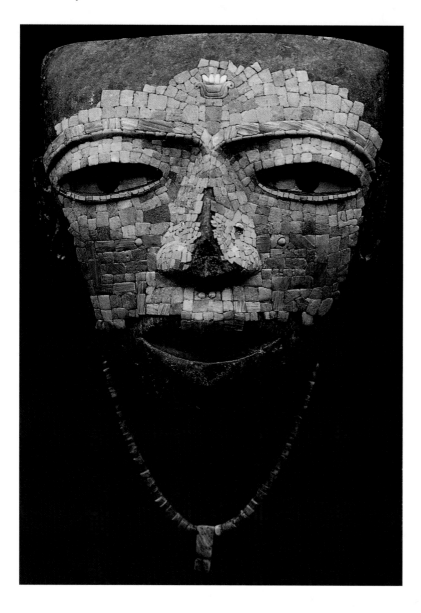

The Mixtecs

The Mixtecs lived in the Oaxaca region, along the Pacific Ocean, from about 600 to 1500 A.D. They were invaded first by the Toltecs and then the Aztecs. Mixtec culture quickly declined with the arrival of the Spanish several decades later.

The Mixtecs often used gold, jade, and turquoise in their jewelry, mosaics, and ceramics. In the tombs of Mount Albán, archaeologists have discovered finger rings decorated with eagle designs, as well as turquoise mosaics and pendants depicting gods and sacred symbols. Jewelry had both a decorative and a sacred role. Special necklaces were worn only by dignitaries.

Among the beautiful examples of Mixtec ceramics are burnished pots with reddish slips. A slip is a mixture of clay and water that is used to decorate the outside of pottery. The Mixtecs also made complex polychrome, or multicolored, bowls; one features a bright blue hummingbird perched on its rim. In addition, they made painted toys from pottery. These delightful figurines often included the black-spotted jaguar, and women carrying children and small animals.

Weaving was another refined craft among the Mixtecs. Women made and wore woven wraparound skirts, held in place by waist sashes. Both men and women wore a *quechquemitl*. Sometimes weavers used wild silk produced by silkworms that lived in mulberry trees growing in the mountains. The weavers spun the silk with a spindle, which they made out of wood.

The Aztecs

When the ships of the Spanish conquistador, or conqueror, Hernando Cortés began to arrive in the New World in 1519, people along the coast said that they had seen "mountains moving on the sea." Many of them believed that the god Quetzalcoatl was returning to land from his world in the ocean. The Aztecs greeted Cortés as if he were a god. They dressed him in a turquoise serpent mask, a quetzal-feather head fan, and a necklace. (You can still view some of these gifts in European museums.) But by the summer of 1521, the Aztec empire lay in ruins, having been defeated by 600 Spanish soldiers armed with muskets, horses, dogs, and a large force of Indian warriors.

Until they discovered the Aztecs, the Spanish had thought that the native peoples of Mexico were simple and barbaric. Cortés and his soldiers, however, were amazed when they arrived at the gates of the Aztec capital city of

Tenochtitlán. Here, they found 200,000 people ruled by the supreme king Moctezuma, who lived in splendor in a palace surrounded by fine gardens and aviaries. An aviary is a place where birds are kept.

Moctezuma's vast domain stretched from the Pacific Ocean to the Gulf of Mexico and included a total of 5 million subjects. He was as wealthy as the kings and queens of Europe. But all of the Aztecs' riches could not protect them from the horses, guns, and diseases of the Spanish conquistadores.

Much of Aztec life revolved around symbolism and ritual, especially human sacrifice. Most sacrifices were held to honor the war god Huitzilopochtli, the Aztecs' supreme deity. The Aztecs believed that the sun, earth, and moon, as well as the gods of plants and animals, would not survive without human sacrifices. It was their sacred duty to feed these entities and gods with *chalchiuhatl*, "the precious liquid," a form of nectar they thought was found in human blood.

The Aztecs most often sacrificed prisoners who were captured during military expeditions. But many young Aztecs were raised with the knowledge they would also be sacrificed one day. To be sacrificed was considered a great honor. Many Aztec arts and crafts, from the great temples to the sacrificial knives, were created for these sacrificial ceremonies.

Most sacrifices took place at The Great Temple in Tenochtitlán, where Mexico City is now located. Today, this temple is open as the Templo Mayor Museum. On this site archaeologists have found great stone sculptures of the "Old God" Heuheuteotl, the fertility god Xipe Totec, and the goggle-eyed Tlaloc, the god of rain and the second-most important deity, after Huitzilopochtli. The plumed, or feathered, serpent has also been commonly found, as it symbolized the god Quetzalcoatl.

Many local rulers who lived within the Aztec empire paid tribute to the Aztec kings. This was one way Aztec kings received new materials for their arts and crafts. Their subjects from distant areas brought them gold dust and tropical-bird feathers, as well as jaguar skins for the costumes worn by the most powerful soldiers, called Jaguar Knights.

Architecture The architecture of Tenochtitlán was a work of art itself. The Aztecs believed their capital city was the center of the universe; the place where their supreme ruler met with the gods. It was built on an island connected to the mainland by causeways. Where the causeways intersected in the middle of the city, they built their principal ritual area, with its pyramids and temples. The area was surrounded by a wall of serpents' heads carved in stone.

Pottery The most common existing examples of Aztec pottery are thin-walled vessels on three legs and bowls painted in flowing black designs on a brown or red background. Other examples feature designs of birds, fish, and plants painted with loose brushwork. The best Aztec pottery is admired because of its delicacy. Some of it is as thin as an eggshell.

Sculpture The Aztecs developed a distinctive and expressive style of sculpture that reflected their focus on human sacrifice and their strong sense of duty to the gods.

An Aztec artist sculpted this jaguar altar to hold human hearts during sacrifices.

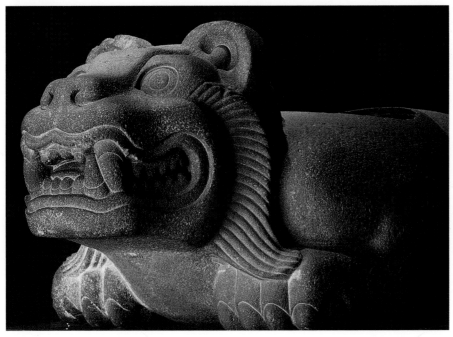

Common images included isolated heads and faces that conveyed a peaceful submission to sacrifice. Stone monuments also featured mythical symbols, such as a sun disk flanked by figures that symbolize the day and night skies.

Featherwork Aztec featherwork was a highly evolved craft. Artisans used feathers to decorate warrior costumes, including headgear, quilted cotton tunics, and shields that were used by high-ranking officers in the army, such as captains and generals. Artisans also created beautiful fans of bamboo and multicolored feathers, sometimes painting a delicate design—for example, a butterfly—in the middle. They used dyes made from plants, flowers, and berries to color the feathers.

Featherworkers lived in groups assigned to separate quarters of the capital. One group made garments only for the war god, Huitzilopochtli, while another made clothing just for the living ruler, Moctezuma. A third group of featherworkers prepared gifts for Moctezuma to give to his allies, while yet another made military badges and emblems for the warriors.

Lapidary The Aztecs also practiced lapidary. They used such materials as chalcedony, jasper, obsidian, agate, quartz, turquoise, and hematite to make weapons and cutting tools rather than jewelry or ornaments. They also used jade, because its green color symbolized rebirth through water and new vegetation. Skilled craftsmen shaped rock crystal, amethyst, and jadeite pebbles with stone knives and sandstone, then polished the surfaces with abrasive powders, bamboo fibers, and tools of hardened copper. They also drilled the stones, using copper tubes or bird bones.

Painting Very little remains of Aztec painting, except for a few murals and the designs on pottery and featherwork ornaments. But archaeologists have determined that Aztec artists painted richly colored and highly detailed murals that

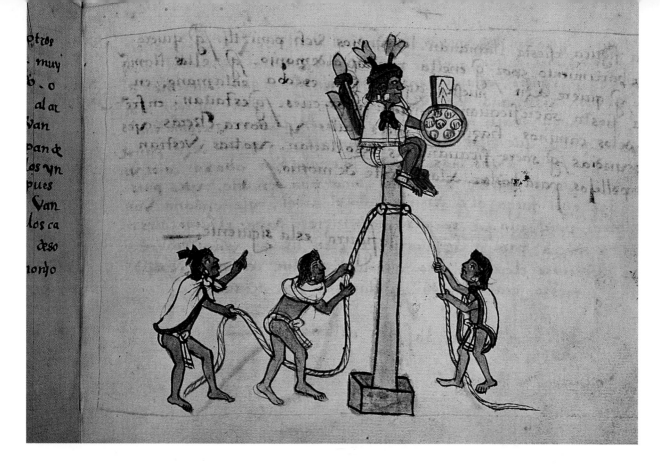

were used in religious ceremonies. Most of the murals
depict common themes, such as nature, fertility, sacrifice,
and war. Humans, gods, and animals—especially the jaguar—
are also shown in repeating patterns.

Archaeologists also believe that the Aztecs were highly
skilled in book illustration. The images they painted in their
books on handmade paper are now called pictorial codices. All
of them are historic. They show nobles dressed in their royal
costumes and jaguar warriors battling enemies. Others are
lists of tribute from conquered cities. They show how much
food, and how many feather and jaguar skins, were brought
to Tenochtitlán.

Textiles Archaeologists do not know much about Aztec
textiles, because the few that have survived are in poor
condition. Because of the warm and moist tropical air, most
of the materials have disintegrated. Records kept by the
Spanish conquistadores, and from the codices, however,
describe a great variety of Aztec textiles at the time of the
conquest. These textiles were often hung on temple walls
or were used in bridal dowries or as shrouds, to wrap the
dead. Decorated blankets were also worn over the shoulder
and signified the rank of the person wearing them.

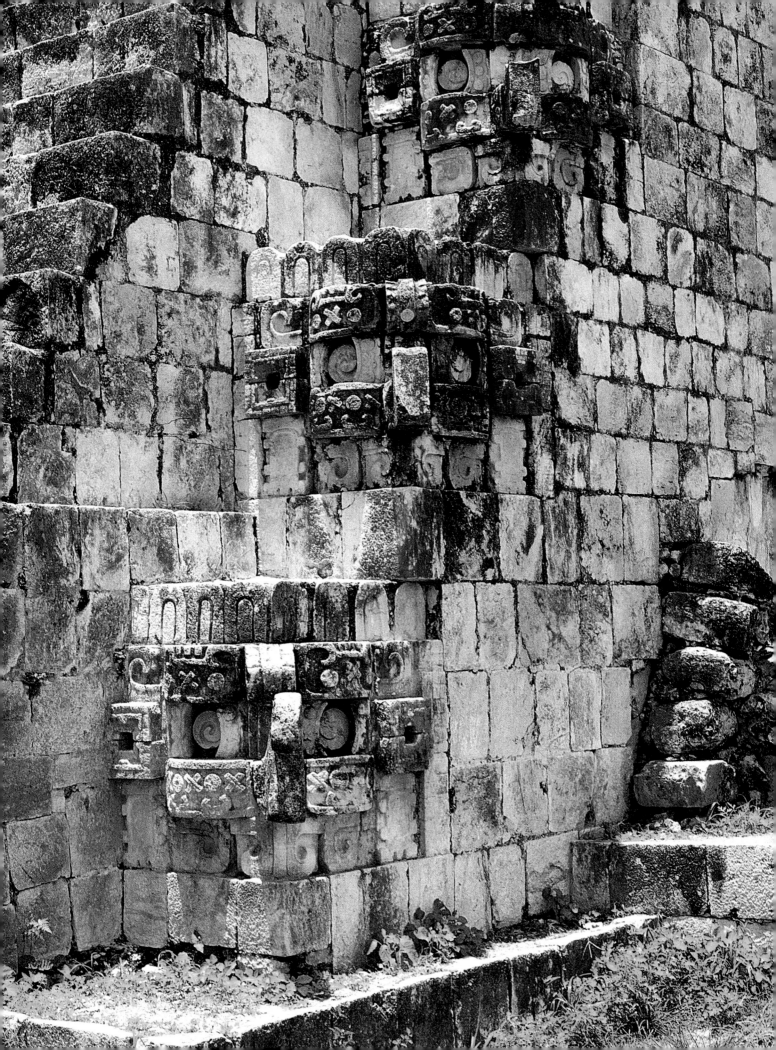

Chapter

3

Southern Mexico and Central America: The Maya

Mayan civilization is considered to have been one of the most sophisticated cultures of ancient America. At its height, the empire flourished in the Central American lowlands, covering the southern Yucatán Peninsula, Guatemala, and western Honduras. Chichén Itzá and Mayapán were two of the greatest Mayan cities. Their ruins have provided archaeologists with superb examples of Mayan architecture, art, and crafts.

By the time the Spanish conquistador Hernando Cortés arrived in 1525, Mayan civilization was already starting to disappear. Some areas had become overpopulated, and many people were dying of malnutrition and disease. In addition, warfare increased between cities and there was growing dissatisfaction among the common people.

Temples and pyramids The Maya built great, bustling cities and trading centers that featured huge temples, palaces, plazas, and pyramids. Both external and internal walls were often adorned with sculptures of gods and mythical creatures, as well as images of nobles dressed in elaborate costumes.

Many temples also featured huge stone figures called *chacmools,* which reclined at the top of long broad stairways with bowls cupped in their hands. *Chacmools* were often part of the human-sacrifice ritual, an important ceremony in Mayan society and mythology.

Archaeologists have been able to trace the different periods of Mayan civilization through its architecture. For example, the Maya often built onto existing temples and plazas as their culture became more sophisticated. Many temples were built and rebuilt over the centuries.

Hieroglyphics The Maya developed a complex form of written communication, called hieroglyphics, or sacred carvings. *Hiero* means "sacred," and *glyphs* are carvings. Hieroglyphics are made up of many different glyphs. Each glyph is part of a text that usually tells a piece of Mayan history or mythology.

A Franciscan friar, Fray Diego de Landa, wrote that the Maya "made use of certain characters or letters, with which they wrote in their books ancient matters and their sciences." Because the friar believed that the characters were written by "the devil," he ordered all the books burned. Due to de Landa's actions, one of the great libraries of the world was destroyed.

It took many centuries for epigraphists to decipher the Mayan hieroglyphics carved on stone monuments, or stelae, tombs, and buildings, and those painted in bark-paper books. Epigraphists are scholars who study ancient inscriptions and carvings.

The Maya used hieroglyphics to communicate with one another. Here, stone hieroglyphics appear on a Mayan wall in the city of Palenque.

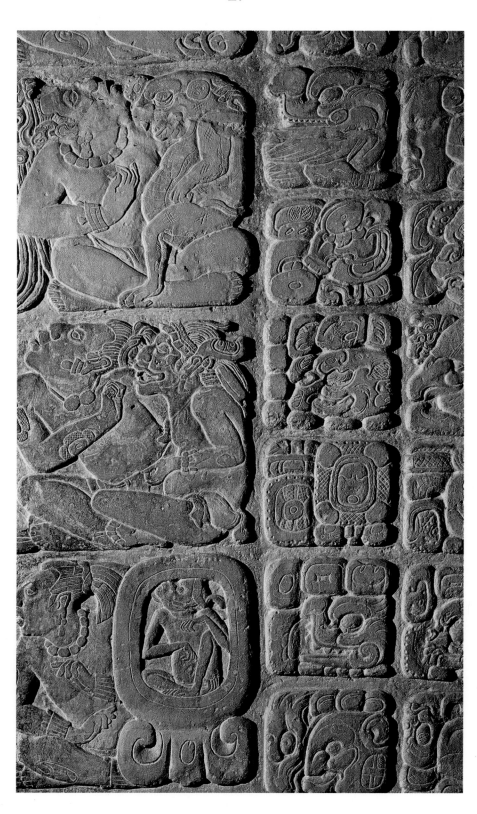

The longest set of Mayan texts is featured on the Great Hieroglyphic Stairway in the city of Copán. It contains more than 2,000 glyphs. Epigraphists have had a difficult time deciphering the texts because a long-ago earthquake broke many of them apart, and no one yet knows exactly how to put the pieces back together.

Stelae The Maya are well known for their intricately carved, freestanding stone monuments, called stelae. Stelae were often carved from limestone. The hieroglyphic texts on the stelae tell the story of the Mayan dynasties and give important dates in the lives of individual rulers. These glyphs have provided epigraphists with important information about the history of the Maya, especially about their government. From these, we now know the names of many Mayan rulers and what they named their cities.

A Mayan artist painted this colorful mural on a wall in the temple at Bonampak. Murals were painted to recognize special events in Mayan history or to convey religious beliefs.

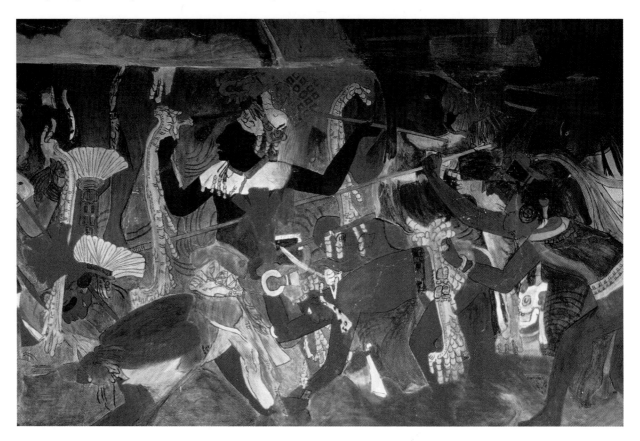

Murals Many temple walls were painted with brightly colored and highly detailed murals. The artists used twig brushes tipped with feathers to paint the murals, which often depicted battle and victory scenes.

In one mural, a prisoner begs for his life before a triumphant Maya ruler dressed in jaguar skins. Another temple mural portrays the Maya's mysterious vision of the universe. The artist painted the finely detailed images against a sky-blue background. The picture contains symbols of the sun and the planet Venus. Male worshipers offer gifts to seated goddesses. A watery underworld lies beneath the goddesses.

Books The Maya made books from the bark of fig trees. A craftsman pounded the bark strips with a wooden mallet. Once the bark strips were smooth and soft, a thin, white-plaster coating was applied to create an even writing surface. A scribe then painted on the bark strips, using a combination of illustrations and glyphs. When the images were dry, the bark-strip pages were folded like a screen, making a kind of fold-out book.

Ball courts As many other pre-Columbian civilizations did, the Maya developed their own ball game. They devised their own unique rules and wore special costumes. A ball game similar to soccer, in which a rubber ball is moved without the use of hands by two opposing teams was invented in this region. Many ball courts are found from the Yucatán Peninsula all the way north to Arizona. The Mayan courts were surrounded by stone stairways and circular stone slabs carved with the images of ballplayers. The game was fast and hard, and it combined athletic ability with ceremony. For example, some players wore huge head-dresses decorated with long feathers, jaguar tails, and jade ornaments. Players also wore protective kneepads made of jaguar skins.

Jewelry In Mayan society, jade, or *chalchihuitl* (actually an Aztec word meaning "green stone") was valued more highly than gold. Those who owned jade had high status in the community. Craftsmen carved elegant figures and glyphs on jade ornaments. In addition, sacrificial knives were carved out of a precious green variety of obsidian.

Some funeral masks were made of jade, pyrite, and shell. Such masks covered the faces of noblemen and noblewomen who had died and were buried in tombs with many of the beautiful objects they had owned.

Textiles Mayan women often wove and wore wraparound skirts held in place by waist sashes. Over these skirts they wore a long tunic, called a *huipil*. Many Mayan women today wear such traditional garments, with similar designs.

Pottery Thousands of ceramic figurines have been found in Mayan graves. Most are believed to be portraits of the people with whom they were buried. Some figurines, in which a mouthpiece emerges from the head, also had hollow bodies and were used as ritual rattles or whistles.

The Maya considered jade to be very valuable, and only elite Maya owned jade jewelry, such as this necklace.

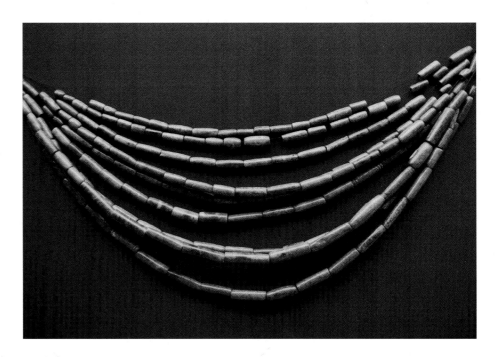

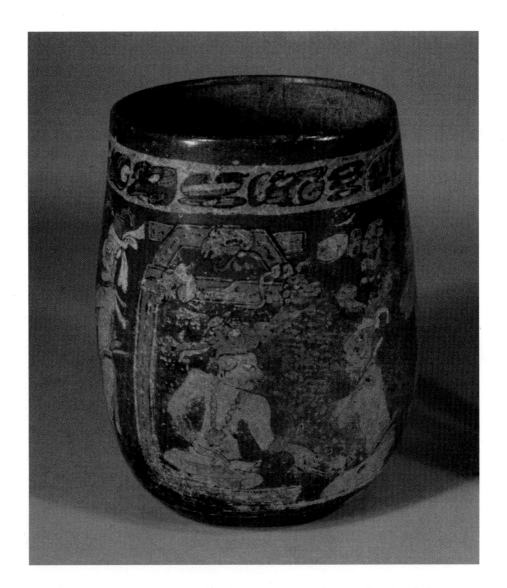

Mayan artists decorated polychrome vases with scenes from important political and religious events.

In some cases, the figurines were of members of the nobility in traditional clothing and elaborate headdresses. Images also included musicians, ballplayers, priests, and weavers, all presented with their typical clothing and objects such as rattles, shields, and looms.

The Maya also made a great variety of polychrome, or multicolored, vases, often decorated with glyphs. Archaeologists have discovered some beautiful examples in the tombs of Mayan nobles. For example, one vase features a warrior wearing a feathered back piece and carrying a spear. On another vase, trumpet players entertain a ruler. The Maya made their trumpets out of pink conch shells, which were often painted with hieroglyphics.

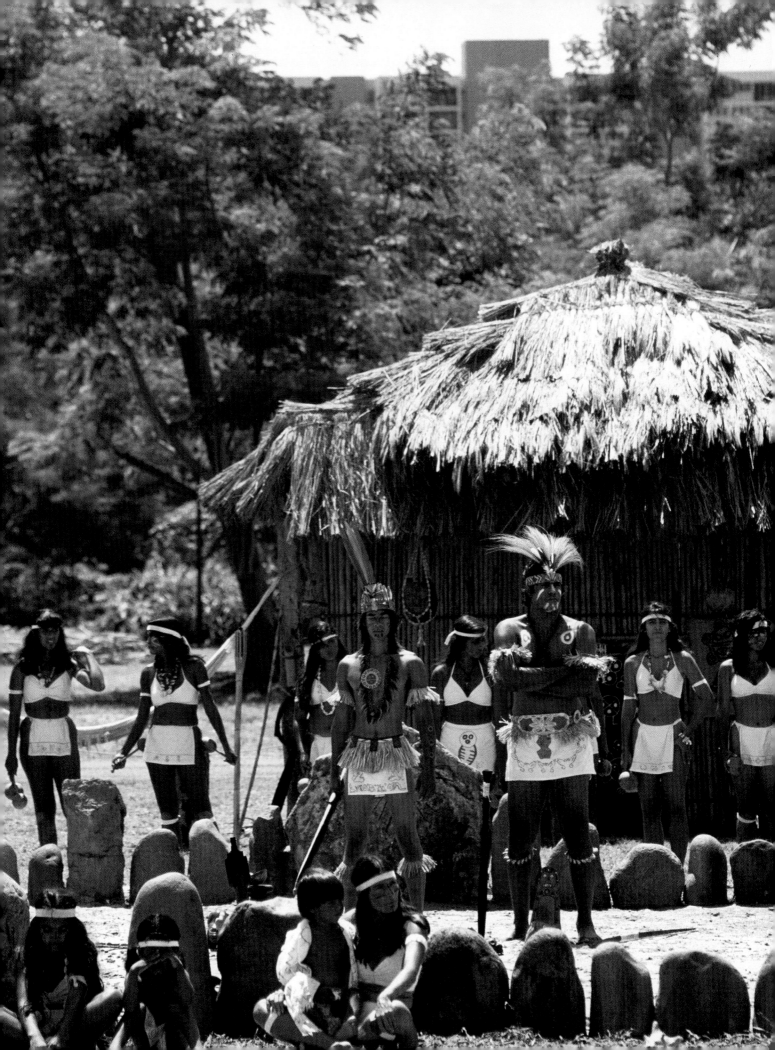

Chapter

4

The Caribbean Coast

The thousands of Caribbean islands create a long, narrow chain almost 2,500 miles long. Located between Central and South America, the islands wrap around a body of water called the Caribbean Sea. In general, the Caribbean islands are divided into four major groups: the Greater Antilles, the Bahamas archipelago, the Lesser Antilles, and the southern islands along the South American coast.

The Greater Antilles includes Cuba, Jamaica, Hispaniola, and Puerto Rico. The Bahamas archipelago includes the Bahama, Turks and Caicos islands. The Lesser Antilles is made up of the U.S. Virgin Islands and the British Virgin Islands. The Curaçao group, along the South American coast, is comprised of Aruba, Bonaire, and Curaçao. Because they are near the equator, the Caribbean islands generally have a warm and moist tropical climate.

Opposite:
In Puerto Rico,
present-day Taino
dress in paint and
loincloths to re-enact
a scene from their
ancestors' lives.

35

When the Spanish first arrived in the Caribbean, they discovered three groups of native people scattered among the islands: the Ciboneys (or Siboneys), the Arawaks, and the Caribs. The Arawaks are also known as the Taino, and they were the first native group to greet Christopher Columbus and his men on the island of San Salvador. The Ciboneys are considered to be the most technologically simple of the three groups, while the Arawaks and the Caribs developed more advanced technologies and lifestyles. Another tribe living along the Caribbean coast was the Cuna, which, like the Carib, often fought other Indians.

The Ciboneys

The Ciboneys are believed to have been the first native people to settle in the Caribbean. After their migration from South America many centuries ago, they settled on the northwestern tips of Cuba and Hispaniola. Like other natives who lived in tropical areas, they wore few clothes and painted their bodies. Their only tools were chipped and ground stone tools. Archaeologists have found no signs of pottery, utensils, or other man-made objects in the rock shelters and caves they once lived in.

The Arawaks

The Arawak people originally traveled from the Amazon Basin in South America to settle in the Caribbean. By the time the Spanish reached the islands in 1492, the Arawaks dominated the Bahamas, the Greater Antilles, and Trinidad. The Arawaks told the Spanish that they had come to the islands to escape the Caribs, who were chasing them.

All of the Arawaks lived near the coast, because seafood was an important part of their diet. They also farmed, growing root plants that provided starch and sugar. Their farming methods were so simple that no tools were needed.

This engraving shows an Arawak man and woman with food they have caught from the sea and have gathered from land.

Using sticks, the women planted shredded pieces of root plants that quickly developed into new plants. They also grew corn, which they pounded into meal in a mortar made from the trunk of a hardwood tree.

Because the climate was so comfortable and the food so plentiful, the Arawaks had plenty of time to develop their arts and crafts. They made dugout canoes, built beehive-shaped huts thatched with palm leaves, wove their clothing from wild cotton, and made pottery and baskets.

The Arawaks used the coil method to make their pottery. They took pieces of clay, rolled them into long ropes, and coiled them to create the shape of a vessel. They often colored their cups, bowls, and jugs red, and painted them with white designs. One popular pottery item was the pepper pot, in which meat, fish, and vegetables cooked continuously over the fire.

In their huts, the Arawak people hung hammocks that were made of cotton. Because hammocks provided cool

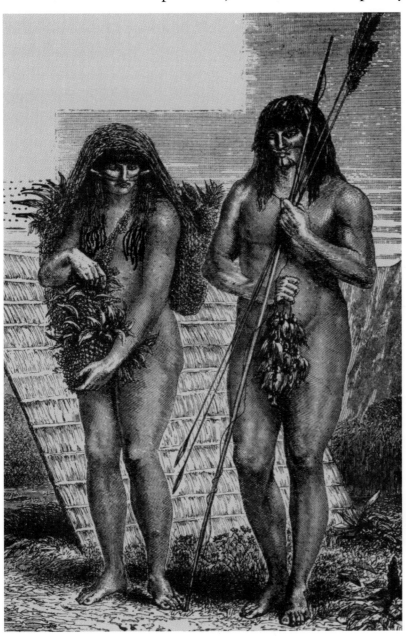

beds for sleeping during warm tropical nights, the Europeans quickly adopted the idea. Soon, most ships traveling in the tropics were full of hammocks rather than beds laid out on planks.

The Arawaks also stained their faces with charcoal and gathered their long hair into nets made of parrot feathers. They made weapons of wooden spears tipped with the tails of stingrays. For their ceremonies, they made curved stools from wood, sometimes in the shapes of iguanas and other island creatures. One Spanish sailor described these stools as "like some animal with short arms and legs, the tail lifted up to lean against, and a head at the other end, with golden eyes and ears."

The Arawaks developed their own complex religion, which taught that good and evil spirits lived in human bodies as well as in many other natural objects. They believed that they could control these spirits by capturing their images in icons or statues called *zemis*, sometimes made of gold (which the Arawaks found in abundance in the riverbeds). Part of an Arawak chief's authority was based on how powerful the spirits in his *zemis* were.

Like many other Latin American groups, the Arawaks also played a ball game. Their version resembled soccer and was played on rectangular courts. Nearly every village had one of these courts.

Both men and women made and wore jewelry crafted from gold, stone, bone, and shell. They pounded gold nuggets into smooth disks and shaped them into ear and nose rings, necklaces, and masks. But the gold later attracted the Spaniards, who forced the Arawaks to get them more of the precious metal. By the mid-1500s, the Arawaks would nearly disappear because of diseases brought over by the Spaniards, slavery, and the constant battles waged against the European invaders.

Opposite:
The Taino, as well as many other native groups, played a ball game similar to present-day soccer. This rectangular ball court was built circa A.D. 1200 in Puerto Rico.

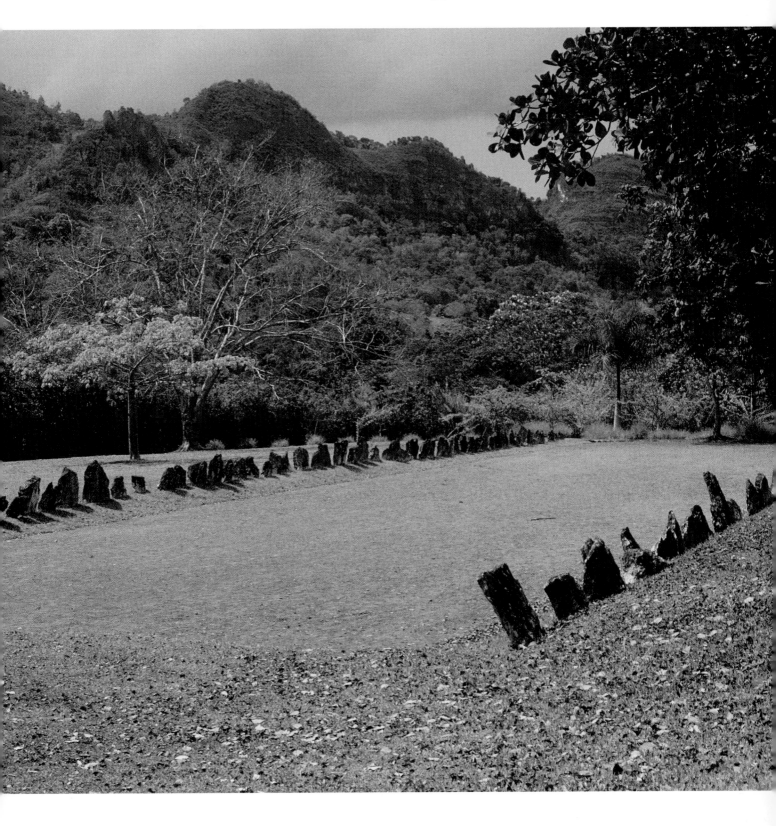

The Cuna

In the jungles of Panama's northern shore, and on the hundreds of coral islands known as the San Blas Islands, the Cuna Indians lived comfortably. The birth of a baby girl caused great joy among the Cuna people. In most other tribes, women had very few rights or possessions. In Cuna society, however, women held most of the land and other property. When a member of the Cuna tribe died, his or her daughters, not the sons, received the inheritance.

Cuna homes actually consisted of two buildings: a large one used for sleeping, and another used for cooking and other chores. Each city also had a *chicha* house. People gathered here for joyous festivals and religious ceremonies. Another community building, called the *casa del congres* by the Spaniards, was used by the Cuna for political meetings and for planning war strategies.

A Cuna woman from the San Blas Islands displays brightly colored molas, *embroidered pieces of fabric.*

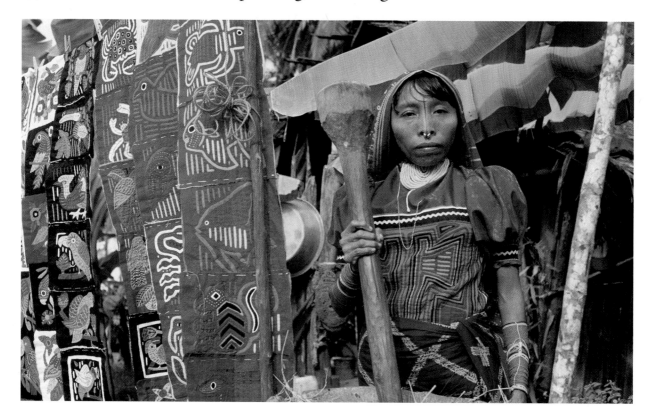

The Cuna were often at war, either with other Cuna villages or with different tribes. They sometimes fought over important resources and land rights, but they usually went to war to capture slaves. Although the Cuna had a reputation for being quite warlike, they were mild compared to the Indians across the sea, the Caribs.

The Caribs

The Carib people lived mostly on the Virgin Islands, the Lesser Antilles, and the northwestern tip of Trinidad. Their diet and many of their activities were similar to those of the Arawaks. For example, they enjoyed a diet rich in seafood and root plants, such as yams. They also hunted reptiles and birds.

In Carib society, the women were responsible for weaving cloth and making household baskets and pottery. The women carried food and other goods in large baskets on their backs, which were held up by straps placed across their foreheads. Carib men also had their responsibilities. They spent a good deal of their time building boats used for fishing and invading other villages.

The Caribs also built handsome houses, which were admired by the Spaniards. The houses were constructed of thick reeds interlaced in the form of canopies. The Caribs did all of their woodworking with stone tools. They also developed a strong and effective bow and arrow. The bows were long and tipped with sharp bones, so that an arrow could be easily withdrawn from its target.

In general, the Caribs were more warlike than the Arawaks. Of the three major Caribbean native groups, the Caribs fought the hardest against the Spanish until the early 1600s, when the British and the French began to fight over the islands. The Caribs sometimes allied themselves with the French against the British.

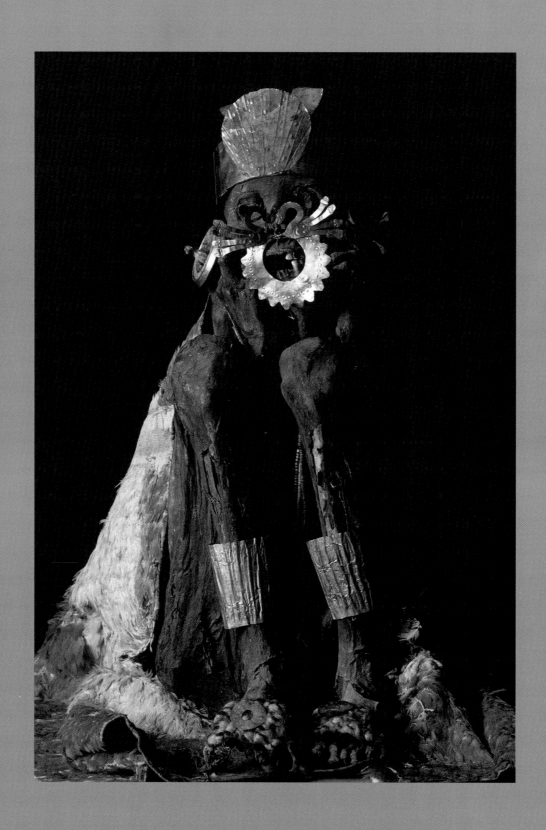

The Andes

The Andes mountain system runs along the west coast of South America, from Panama to Tierra del Fuego. This region includes the coastal and lowland areas to the west and the highlands to the east. The highly sophisticated Moche kingdom ruled a strip of desert coastline in northern Peru that stretched for 250 miles, from the Lambayeque Valley in the north to the Nepena Valley in the south. Although it was relatively small, in geographical terms, the Moche empire was long-lived and prosperous.

In contrast, the Inca once dominated a huge region, 2,700 miles wide, that stretched from Lake Titicaca in the south to the Ecuadorian coast in the north, and from the Pacific Ocean in the west to the edge of the Amazon rainforest in the east. Although it lasted little more than one hundred years, the Inca empire was the largest civilization to develop south of the equator in the pre-Columbian period.

Opposite:
In pre-Columbian societies, members of the elite were buried with special ornamentation. This Peruvian mummy wears gold jewelry and a feather cloak.

The Inca empire was the last pre-Columbian civilization to fall after the arrival of the Spaniards in the late fifteenth century. In addition, it is believed to have been the largest empire on earth at the time of the Spanish conquest. At its height, 10 million people lived within its boundaries. Four highways crisscrossed the kingdom, giving it the name of "Land of the Four Quarters," or Tawantinsuyu.

The Moche

The Moche dominated northern Peru from A.D. 100 to 800, long before the Inca did. A sophisticated civilization, they built what are considered to be the richest pre-Columbian tombs ever excavated in the Western Hemisphere. Archaeologists believe that because the region was extremely dry, the Moche kingdom collapsed following a period of long droughts. Devastating earthquakes and catastrophic floods occurred soon afterward.

Pyramids The Moche Pyramid of the Sun is one of the largest pyramids built in pre-Columbian America. Its summit featured ceremonial plazas and clusters of temples, shrines, and the brightly painted houses of Moche nobles. The Moche built a number of sacred pyramids, also used for the sacrifice of human prisoners taken during wars with other groups in their region.

Metalwork The Moche were brilliantly skillful with gold, as well as silver. Gold and silver were highly prized because their shimmering colors were identified with the gods of the sun and the moon. The Moche made many beautiful objects out of gold, including headdresses, face masks, bells, earrings, and necklaces. They also decorated such objects with shells and semiprecious stones, such as bluish-green turquoise and sky-blue lapis lazuli.

Using only the simplest of tools, Moche metalworkers melted the gold and silver in small furnaces by blowing on

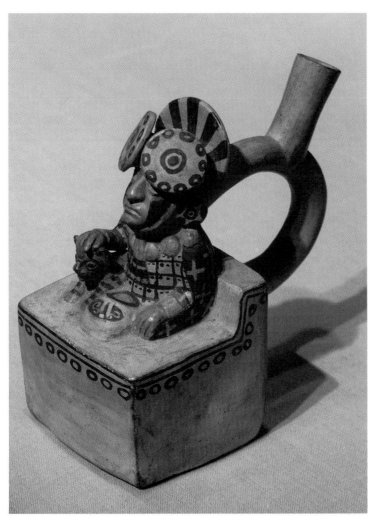

Moche potters often re-created scenes from daily life. This Moche vessel depicts a ruler seated with a cat.

the hot coals through long tubes. They also mixed together gold, silver, and copper, creating an alloy, and used stone hammers to flatten the metals into smooth sheets. The metalworkers would then create tiny sculptures of animals and other objects from the sheets. Some figurines even had movable parts.

Pottery Moche potters were great masters of their craft. They are believed to be the first pot makers in South America to make clay objects from molds. Molds allowed them to reproduce the same objects again and again. With this technique, they produced bowls and pots, painted with red, white, and earth-colored designs. Many of the designs were scenes of daily life, including such complex images as women weaving on looms attached to wooden posts and doctors working on their patients.

In addition, the Moche created bottles with distinctive spouts that curved elegantly from the body of the vessel. On these bottles, artists painted scenes from Moche mythology, including many images of the gods. Others showed great Moche battles, with warriors charging their enemies, clubs raised.

Most Moche ceramics were decorative as well as useful. One statuette features a jaguar attacking a man, while a vase resembles a deer or a deer-priest. Another vase is shaped like a Moche house, with the walls painted in delicate

geometric shapes. Moche lords also used vases that were molded in the form of their own heads and faces. These are called portrait vases.

The Inca

When the Spanish conquistador Francisco Pizarro and his 168 soldiers landed on the northern frontiers of the gold-rich Inca empire, they headed straight for the legendary Inca capital, Cuzco. On the way, they met the Supreme Inca, Atahualpa, who was sitting high on a throne atop an open litter carried by his subjects.

The huge throne was made entirely of gold. The litter was lined with the richly colored feathers of tropical birds and studded with gleaming plates of gold and silver. Around his neck, the Inca ruler wore a collar of emeralds.

Having the advantage of horses and muskets, the Spaniards proceeded to slaughter every Inca man in Atahualpa's entourage. To save himself and the rest of his empire, Atahualpa told his people to gather all the gold they could find, including that in the beautiful Temple of the Sun. He hoped the Spaniards would accept the ransom and then leave him alone.

As soon as Atahualpa handed over the treasure, however, the Spaniards began to melt down the gold objects. Shortly afterward, they killed him. Without its great leader, the magnificent Inca empire soon began to collapse.

Stonemasonry The invading Spaniards were astonished by the quality of the stonework they found in Cuzco. To build the great Inca temples and palaces, thousands of men had to dig out and cut the stones, haul them with great cables of leather and hemp, dig ditches and lay foundations, and cut poles and beams for the timbers.

To fit the blocks perfectly, stonemasons spent thousands of hours pounding out a depression in one block so that it

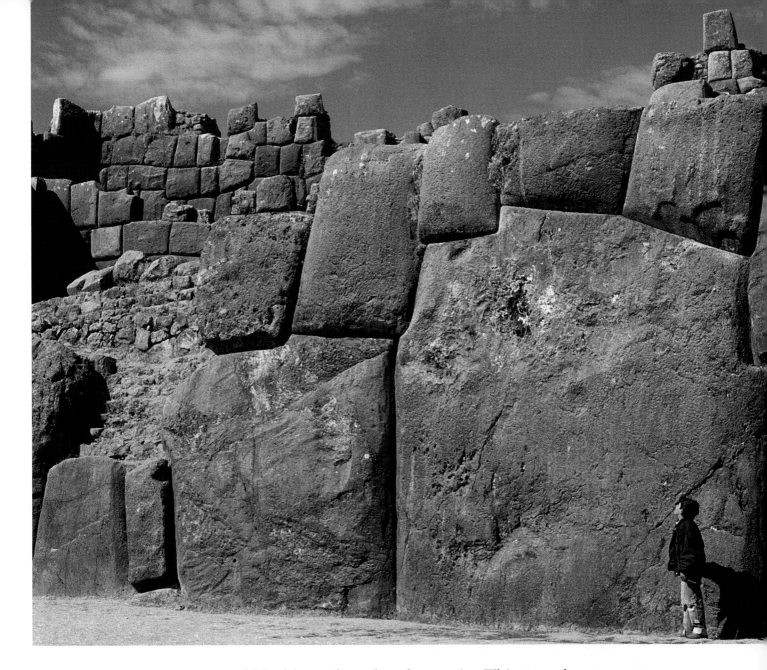

The massive stones that make up the walls of the Incan fortress Sacsayhuaman were fitted together without the use of mortar or cement. Sacsayhuaman was built to protect the Incan capital of Cuzco.

would hold another placed upon it. This way, the two blocks fitted snugly together to make the walls smooth and durable. Unlike European stonemasons, the Inca did not use mortar or cement. The blocks were so tight that not even a Spanish sword could be slipped between them. Many of these stone walls still stand in ancient Inca country and look much like they did 500 years ago.

Architecture More than 9,000 feet above sea level, Cuzco was a royal capital, a spiritual center, and the hub of a vast and well-supplied empire. At its height, Cuzco was also more modern in some ways than Europe was. For example, stone-lined channels provided efficient sanitation, carrying water quickly down the middle of each city street.

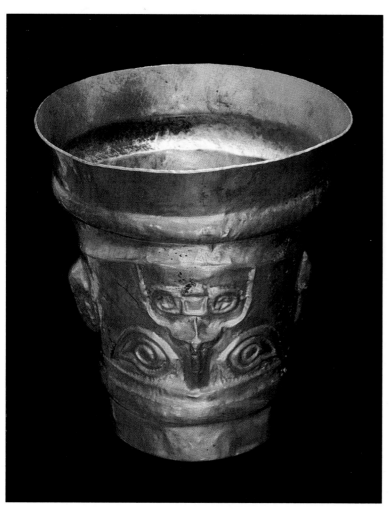

Gold was an extremely precious metal to the Inca, and many objects were made from it. Here, a gold goblet was created by an Incan metalworker. If you turn the picture upside down, you can see a beautiful detail of a face.

Metalwork The Inca believed that gold was the sweat of the sun and silver, the tears of the moon. Perhaps more than any other pre-Columbian group, the Inca created superb metalwork. Exquisite gold and silver objects were made only for the nobility and for religious ceremonies. Sacrificial knives, called *tumis*, were made of gold and inlaid with turquoise.

In Cuzco, the Temple of the Sun, Coricancha, featured golden llamas, pitchers, and jars. The temple contained six one-room buildings that had gold-covered walls grouped around an open courtyard. In the garden "grew" golden corn, with silver stems and ears of gold. One room in the Temple of the Sun housed a golden image of the sun, set with precious stones.

Incan metalworkers produced gold pectorals (chest ornaments), burial masks, crowns, belts, bracelets, earrings, masks, and cups as body adornments. Nobles also wore golden ear plugs inlaid with turquoise and mother-of-pearl. Huge golden ear disks filled out the entire earlobe and sometimes hung down to the shoulders.

Very few of these beautiful artifacts, however, survived the conquest, having been melted down by the Spaniards.

Those that still exist were either taken by the Spanish to Europe or hidden in tombs by the Inca. Today, they are kept in museums and put on display for visitors.

Mummies The cult of royal mummies was at the center of Inca life. Dead kings and lords were mummified with great artistic effort. The arid mountain air mummified bodies naturally, but artisans gave royalty spectacular, ornate treatments.

During important ceremonies, royal mummies sat in special wall niches in the Temple of the Sun. The Inca believed that the mummies were still powerful and that they would return to live again. For this reason, mummies continued to own the land and the palaces that were theirs when they were alive. This was also why each new ruler needed a new palace. Thousands of Incan mummies have been found that were not royalty, but they were buried with little in the way of ornaments or furniture.

Pottery The Inca painted geometric shapes on their pots and utensils. They also painted other designs, including flowers and llamas. Their pots were made by coiling clay around and around and then flattening the coil into a smooth surface.

The Inca also shaped drinking vessels to look like human heads. Incan bowls had wavy rather than even, straight rims. Potters also made figurines, such as the statuettes of goddesses.

Textiles Inca nobles often wore a beautiful cloth woven from the delicate wool of the wild vicuña, an animal related to the llama and alpaca. Especially intelligent and beautiful girls were chosen to learn how to weave and embroider colorful cloaks for the nobility. The common people wore clothing made from the coarser wool of the alpaca.

Some Incan cloaks were woven of wool and cotton and decorated with dense layers of gold and silver pieces. They

were also embellished with ornate embroidery. The amount of embroidery at the waist and the length of the hemline signified the wearer's status. Ceremonial clothing worn by nobles was also decorated with hummingbird feathers.

Featherwork and jaguar skins The Inca used beautiful feathers of such tropical birds as red, white, and blue macaws when making their ceremonial clothing. Full-length cloaks were often decorated with feathers that were arranged in geometric patterns. Incan clothing makers also used the black-spotted skins of the jaguar, which were brought back from the rainforest by hunters and traders.

Tools One of the most amazing and mysterious items used by the Inca in their business affairs was the single-knotted *quipu*. The *quipu* is a very long wool string with many small knots. It is believed that the Inca used it to count and keep track of numbers. They may also have

A colorful pre-Columbian textile was woven with a monkey and jaguar design.

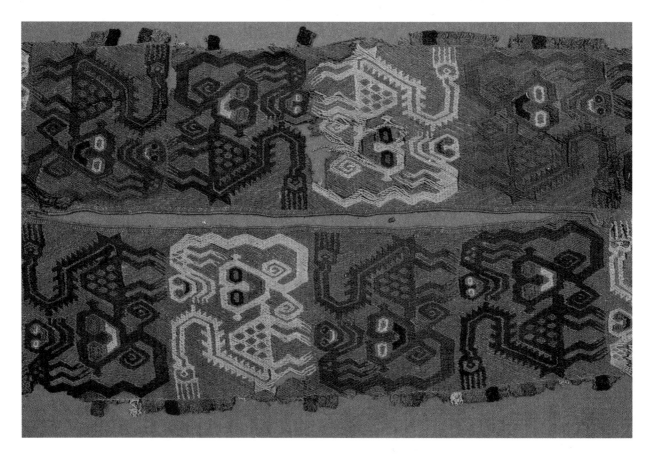

The Inca used string quipus as counting devices.

recorded the movements of the moon and the planet Venus with the *quipu*. Many *quipus* that were owned by coastal Inca have survived because they were buried in the dry sand with their former owners.

Because of the huge geographical size of the Inca empire and the enormous population, efficient communications and transportation were critical. To build the hundreds of miles of roads that thus crossed their kingdom, the Inca made and used such tools as hammers and wedges. They also built great swinging bridges over mountain ravines. To achieve this difficult task, they carved huge holes in the rocks on both sides of a ravine. Then they passed cotton ropes and cables made from thin tree branches through the holes in the rocks.

Boats The Inca also developed an impressive ability to build boats that could travel hundreds of miles out to sea. They used lightweight balsa wood, because water could not pass through it. Huge rectangular cotton sails caught the wind for their ocean voyages. The boats were important for trade along the coast, carrying such valuable goods as gold, silver, wool, and cotton.

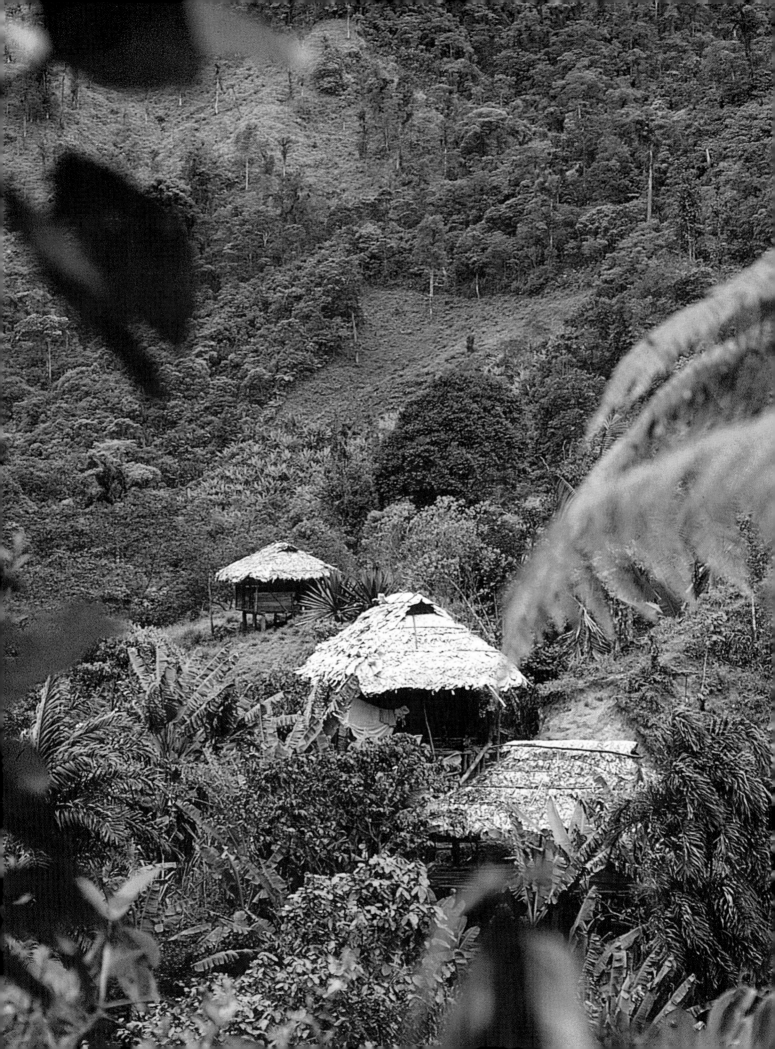

The Amazon Basin

The Amazon forest is the vast tropical jungle land surrounding the Amazon River, which flows for about 3,900 miles through Brazil from the Peruvian border to the Atlantic Ocean. Many native people have lived within the Amazon forest for centuries. It is estimated that the pre-Columbian population in the Amazon was as high as 6 million. But the Spanish brought war, disease, and the slave trade; and within 200 years, many villages along the Amazon River and its main tributaries were deserted.

Because the jungle is often thick and its rivers are treacherous, however, many groups were also protected from the European invasion. These groups have had relatively little contact with the outside world. This isolation has allowed them to develop and maintain their own unique cultures, although many of these groups have similar characteristics.

Opposite:
Many tribes that live in the Amazon Basin have tried to maintain their traditions and ways of life over the centuries. Here, native homes are partially hidden by the tropical forest.

The Amazon Indians also developed their own religions, based on what they saw around them in the forest. They developed a strong belief in spirits and the supernatural. Ceremonial and magical practices still play an important part in their daily life. For centuries, many groups have held festivals related to the sun, moon, seasons, birth, death, and the fertility of plants.

The Yanomami

Today, the Yanomami are considered to be one of the last Stone Age tribes on earth. For centuries, they have been a seminomadic group living and traveling along the border region of northern Brazil and southeastern Venezuela. Because they have not had many material needs, the Yanomami have developed relatively few arts and crafts. They practice many of the same customs today as their ancestors did several hundred years ago.

The Yanomami cut their hair in a bowl fashion, as if they had put a bowl on their head and cut around the rim. Most Yanomami do not wear clothes, except for a small covering on their private areas. For decoration, however, the women sometimes wear armlets made of colorful vertical beads.

Yanomami men and women also paint their bodies in snakelike and circular designs using a red paste made of seeds. Some of the women paint black circles similar to jaguar spots on their faces and bodies. The Yanomami also paint their dead family members before they cremate them.

When they reach puberty, girls have the skin around their mouths and their lower lips pierced with the needles of the palm tree. For the rest of their lives, they regularly wear long, slender sticks inserted through the holes. Sometimes they pierce a hole through to the inside of their noses. In addition, women often insert flowers through holes pierced in their earlobes. Men stick feathers through theirs.

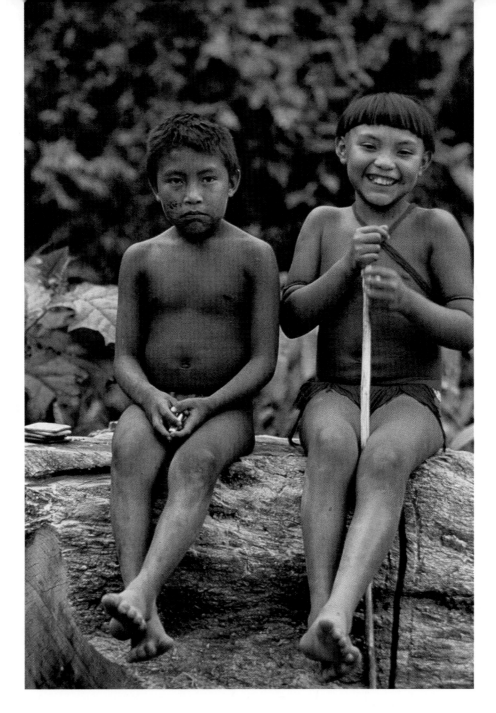

Two Yanomami boys dress in the tradition of their tribe.

The Yanomami build round houses in which several families live. Sometimes these dwellings are enormous, with ceilings as high as seventy-five feet. For cooking pots, the Yanomami use hollowed-out logs. They sleep in hammocks attached to the beams that support the house.

The Barasana

The Barasana are a small group of native people who have lived on the Pirá-Paraná River, along the border of Colombia and Brazil, for many centuries. Like the Yanomami, they often paint their faces and bodies. They make their paints

from the plants around them. Black paint, for example, is made from leaves. Each color is symbolic. Red face paint is a sign of friendliness and protects the wearer from danger.

The Barasana often make necklaces of small glass beads. They often wear the necklaces as jewelry or trade them with other groups for items they need.

The Barasana have a clear division of labor within each family. Men are responsible for weaving baskets, carving stools, and making weapons and fishing gear. The men also make ornaments for ceremonial dances, which only they are allowed to wear. Such ornaments may include a feather crown with egret plumes at the back, a necklace made of quartz, a belt decorated with jaguar teeth, and a painted bark-cloth apron.

Women make pottery and body paint, sew clothes, and weave hammocks from palm-leaf fiber. They make the pottery from clay found on stream banks. Like many native groups, the Barasana shape the clay into long ropes, which they then coil around in the shape of the item they want to make. The sides of the coils are then smoothed with a polished pebble.

Once a pot is shaped, it is baked until it is hard. Then the pot's surface is coated with leaf juice and smoked to give it a black glaze. One popular Barasana pot is the brightly painted *yagé* pot, which holds *yagé*, a popular drink made from the bark of a vine.

The Waorani

The Waorani also use body paint, especially during festivals. Using natural dyes, they often paint one another in large groups. Being painted together is part of the fun. Some mothers even paint their babies, to help them fall asleep.

For special occasions, the Waorani wear elaborate ornaments, made mostly from natural materials. They also wear

necklaces, ear plugs, and nosepieces made from seashells, bones, and animals' teeth. In addition, the Waorani make multicolored bands and crowns from the feathers of the tropical birds that fly through the trees around them. Such birds include the macaw, parrot, and toucan. The Waorani also coat their skin with sweet-smelling tree saps and pungent fruit oils.

To make music, the Waorani use panpipes and flutes carved from animal bones or bamboo. They also make drums from animal skins and maracas, or rattles, which they carve out of gourds or nutshells.

The Kaipo

The Kaipo migrated into the deep jungle of southern Pará, a Brazilian state near the eastern mouth of the Amazon. Like their neighbors, they also paint their bodies. Some Kaipo use the black juice of the genipape fruit to color their faces black. For this reason, they are often referred to as the "people with black faces." Some Kaipo also wear *botocs*, red wooden plates inserted in their lower lips.

Two members of the Kaipo tribe wear feathered headdresses, beaded ornaments, and body paint.

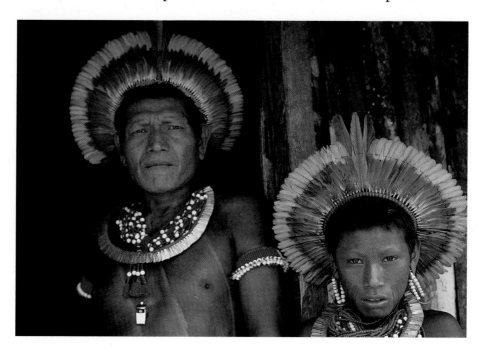

Glossary

anthropologists Scientists who study the relationships between living peoples, their environment, and their culture. Anthropologists try to understand how people live and work, what they believe, and how their values shape their society.

archaeologists Scientists who study the material remains of past human life and activities. Archaeologists often excavate the ruins of ancient civilizations and study the objects they find.

casa del congres A community building used for political and war-strategy meetings.

chacmool A stone figure that most often reclines at the top of pyramid stairs. Chacmools hold a bowl on their bellies designed to hold the hearts of sacrifice victims.

chalchihuitl Jade, a semi-precious stone of various shades of green, considered very valuable in Mayan society.

chalchiuhatl To the Aztecs, a form of nectar for the gods, found in human blood.

chicha Among some native groups, a house used for festivals and religious ceremonies.

conquistador A conqueror, particularly a soldier or an explorer from Spain.

Coricancha The Inca Temple of the Sun. This temple is famous for its many gold items, including gardens "planted" with golden corn.

epigraphists Scholars who study ancient carvings and inscriptions such as Mayan hieroglyphics.

hieroglyphics Sacred carvings found in many Mayan temples and monuments, as well as Mayan books. *Hiero* means "sacred" in Latin, and *glyphs* are carvings. The sacred carvings are considered a form of writing.

huipil Among the Maya, a long tunic worn over skirts.

jaguar A large, spotted member of the cat family that roamed much of Central America. Because of its hunting skills, the jaguar appears in many pre-Columbian crafts.

lapidary The art of shaping gems and semi-precious stones. Many pre-Columbian groups were highly skilled in lapidary.

lapis lazuli A bluish semi-precious stone.

mola An embroidered piece of fabric traditionally made by the Cuna women of Panama.

olla A large earthenware jug.

polychrome Multicolored. This term is used to describe pottery designs that use more than two colors.

pre-Columbian The period before the arrival to the New World of Christopher Columbus in 1492. This term is often used to describe arts and crafts that show no Spanish influence.

quechquemitl A closed shoulder-cape developed around A.D. 400 and worn by many Mexican groups, including the Huichol and the Mixtec. The *quechquemitl* is still worn today in Central America.

Quetzalcoatl The most powerful god for the Toltecs and Aztecs; also known as the Feathered Serpent.

quipu A knotted string used by the Inca. The string is believed to have had many uses, including keeping track of numbers as well as recording the movement of the moon and planets.

Spanish conquest The period beginning in 1492, during which Spanish soldiers, or conquistadors, conquered much of Latin America. The Spanish conquest greatly changed the lives of the people living in this region.

stelae Carved stone monuments found in Mayan ruins. Stelae are often carved with hieroglyphics that record important events in Mayan history.

tesguino Beer made from fermented corn.

tsikuri A piece of woven cloth in Mexico, otherwise known as gods' eyes. The dark section of the *tsikuri* is believed to allow the gods to watch their followers.

tumi An Incan sacrificial knife. *Tumis* were often made with precious metals and decorated with semi-precious stones, such as gold and turquoise.

turquoise A greenish semi-precious stone used in many native Latin American crafts, especially jewelry.

yagé A beverage made from the bark of a vine.

zemi An icon or statue that the Arawaks created to contain good and evil spirits. *Zemis* were often made of gold and were owned only by Arawak chiefs.

Further Reading

Corwin, Judith Hoffman. *Latin American and Caribbean Crafts.* New York: Franklin Watts, 1992.

Gifford, Douglas. *Warriors, Gods and Spirits from Central and South American Mythology.* Schocken Books, 1983.

Greene, Jacqueline Dembar. *The Maya.* New York: Franklin, Watts, 1992.

Kennedy, John G. *The Tarahumara.* New York: Chelsea House, 1990.

Lourie, Peter. *Amazon: A Young Reader's Look at the Last Frontier.* New York: St. Martin's Press, 1991.

Marrin, Albert. *Inca and Spaniard: Pizarro and the Conquest of Peru.* New York: Atheneum, 1989.

Reynolds, Jan. *Amazon Basin.* New York: Harcourt, Brace & Co., 1993.

Sherrow, Victoria. *The Aztec Indians.* New York: Chelsea House Publishers, 1993.

_____. *The Maya Indians.* New York: Chelsea House Publishers, 1994.

Sonneborn, Liz. *Native American Culture: Arts and Crafts.* Vero Beach, FL: Rourke Publications, Inc., 1994.

Index

Photo Credits

Cover and pages 16, 20, 23, 29, 30, 32, 42, 45, 47, 50, 51: ©Robert Frerck/Odyssey Productions/Chicago; pp. 6, 10, 26: ©Robert B. Pickering; p. 8: ©Rebecca Augustin/ DDB Stock Photo; pp. 11, 33, 48: ©Denver Museum of Natural History/Department of Anthropology; pp. 13, 39: ©Chip and Rosa Maria de la Cueva Peterson; p. 14: ©Erich Lessing/Art Resource, NY; p. 18,: ©DDB Stock Photo; p. 25: ©Scala/Art Resource, NY: p. 34: ©Suzanne Murphy-Larronde/DDB Stock Photo; p. 37: North Wind Picture Archives; p. 40: ©Ken Cole/Earth Scenes; p. 52: ©Doug Wechsler/Earth Scenes; p. 55: ©Leonide Principe/Photo Researchers, Inc.; p. 57: ©Nair Benedicto/DDB Stock Photography.